Landscapes, with Horses

ALSO BY MARK SANDERS

First Hunt
Gone Fishing
The Suicide
Before We Lost Our Ways
A Dissimulation of Birds: Stories
Here in the Big Empty
Conditions of Grace: New and Selected Poems
Landscapes, with Horses (fine press edition)
Riddled with Light: Metaphor in the Poetry of W. B. Yeats

EDITED WORKS

The Sandhills & Other Geographies: An Anthology of Nebraska Poetry
The Sandhills II: Poets of the Great Plains
Jumping Pond: Poems and Stories from the Ozarks (with Michael Burns)
On Common Ground: The Poetry of William Kloefkorn, Ted Kooser, Greg Kuzma, and Don Welch (with J. V. Brummels)
The Plains Poetry Series, vols. 1-8
The Main-Travelled Roads Chapbook Series, vols. 1-22
The PlainSense of Things, vols. 1-3
Three Generations of Nebraska Poets (with Stephen Meats)
A Sandhills Reader: 30 Years of Great Writing from the Great Plains
The Red Book: The Selected Poems of Kathleene West
The Weight of the Weather: Regarding the Poetry of Ted Kooser
Verdigris Creek Bridge: A Literary Reunion

Landscapes, with Horses

poems by Mark Sanders
woodcuts by Charles D. Jones

Foreword by Claire Davis

with best wishes and regards!

STEPHEN F. AUSTIN STATE UNIVERSITY PRESS
NACOGDOCHES, TEXAS

ISBN: 978-1-62288-068-3

All illustrations in this work are by Charles D. Jones and were previously published in the 2012 fine-press edition from LaNana Creek Press, Copyright © 2012 by Charles D. Jones.

Printed in China

For more information:
Stephen F. Austin State University Press
P.O. Box 13007, SFA Station
Nacogdoches, TX 75962
sfapress@sfasu.edu
www.sfasu.edu/sfapress

Distributed by Texas A&M Consortium
www.tamupress.com

LIBRARY OF CONGRESS CATALOGING-IN-PUBLICATION DATA

Sanders, Mark
Landscapes, with Horses / Mark Sanders
1. Poetry. 2. American Poetry. 3. Nebraska Literature. 4. Great Plains Literature. 5. Texas Literature. 6. Sanders, Mark

Jones, Charles D.
Landscapes, with Horses / Charles D. Jones
1. Art. 2. American Art. 3. Texas Art. 4. Woodcuts. 5. Fine-arts Books. 6. Jones, Charles D.

TABLE OF CONTENTS

for Comet and Jed,
and for Kimberly, keeper of our herd

INTRODUCTION

by Claire Davis (author of *Winter Range* and *Labors of the Heart*), Lewiston, Idaho

I run the brush down the lay of my horse's back, over his haunches and croup, then slip the saddle pad on, follow with the saddle and cinch tight. I am at Hell's Gate State Park in north-central Idaho; it's early fall, and the fescue has been seared to the color of wheat, the hills all about me rising golden and ocher, and threaded below by the deep blue line of the Snake River. In my sixties now, it is second nature to me, the care with which I tend the horse, less inclined to rush through one moment or the next. Rather, I savor the feel of the hairs, the smell of horse in the warming sun, the sound of his breath against my shoulder and the braided rein in hand. Horses. The touchstone I have come back to time and again, regardless of the illogic of it at my age, or the general impracticality of owning horses, or as I've not-so-jokingly called them, the "sucking black holes of finances."

As a child I lived with my family in the rural Wisconsin of the Fifties, surrounded by dairy farms, and . . . horses, mostly loose-lipped nags the neighboring farmers kept for their grandchildren to ride. There was the occasional showy Arab, or the quiet quarter horse for pleasure, or more commonly the draft horses—remnants of an earlier age—with their platter feet and axe-handle faces.

Belly-down in tall grasses, I spent summer days just the other side of the electric fences watching the ragged herds, and when I wasn't directly with them, my bike became my horse. My legs became my horse. I rode the horse to bed and into dreams at night. Then there was the local riding academy, where my sister and I sat great, gas-bellied school horses with names like Blue Bell, Star and Punch, hopped them over ground poles and cross rails. Afterward I was allowed to groom them to my heart's content, smelling the deep, sweet smell of sweated hide, of grass and oats and leather. Finally, as a young woman just out in the working world, the first significant purchase I made? Not a car. Not an apartment, or designer clothes, or any of the things you might associate with some small measure of financial freedom. Instead, I bought a Tennessee Walker—a strawberry roan named Fabulous Faye who carried me with grace under saddle and bareback through the fields of Wisconsin. Carried me all throughout my young adulthood, through my first marriage and the birth of my son, Brian.

It is not so unusual, this connection to horses. For it seems to me, horses are one of those near-universal attractions. Some of us are, of course, more deeply attracted than others, yet even those who say they are frightened of horses, or don't trust horses, at some deeper level admire and respect them. But for many of us, what starts out as a child's fascination, or a youngster's romantic notion of galloping across fields unfettered by our too-human limits, the passion changes to something deeper, something multifaceted and abiding. What rises off the pages of Mark Sanders's book, *Landscapes, with Horses*, is this arc of movement, how in observation and experience we come to better understand what is not only *horse* but what it means to be both human and of this world, and how the experience of

horses becomes larger than the thing itself. The animals become portals into the landscapes we wish or need to explore be it physical, philosophical, or spiritual. As Sanders hints in the poem, "Beatitudes, June Dusk," in horses we rediscover our connection to a world that demands we bide our time and seek more deeply what is not only within but also beyond our immediate grasp:

> Blessed is the horse, head bowed in deep Bermuda,
> pond frogs decreeing day's end, egrets lifting
> and falling like snow despite the warm breeze.

In the poem, the reader is introduced to the horse immersed in landscape, its head bowed deep in Bermuda, and following the line of the poem, it is as though we are following the horse's line of sight, and we find ourselves surrounded as the horse is by a landscape of earth and sky as well as the intangible—time. Time is of the essence here, for there is something in horses that not only holds our attention, but holds us in place and grounds us, even as it held me as a small child in the tall grasses. Perhaps it is as simple as the quiet they inhabit of a browse on a summer evening, or the way that quiet invites us in as no other part of our hectic multitasking life currently does.

At the end of my second marriage, at the age of 50, I found myself seeking the company of horses for a very different reason than I did as a young woman. It was no longer the thrill of riding a thousand-plus-pound animal, the head-strong idea of control or prowess. Rather it became a much deeper-seated quest—a way to move beyond grief over the death of a marriage, beyond the pain and into some semblance of joy, and perhaps even forgiveness. This desire to heal, to find our way once again within the natural world is evident in the poem "Why We Bought a Horse": "After our boy died, the black mare / was necessary" The poem goes on to not only address the depth of hurt and need but the complexity of despair itself, the desire to heal pitted against the need for punishment: "for those closest to me, wishing death / upon themselves, desiring dust / beneath the horse's hooves" This suggests an intuitive need to heal even when we believe we desire self-destruction. For to reconnect with the natural world in times of distress means to lose ourselves in something that is larger than our *selves*, something that will re-introduce us to what it means to live again, and more deeply.

Even if we first come to horses out of our need, what we discover in our interactions with them is that the animal demands we move beyond ourselves if we ever hope to fully encounter them as anything more than a salve or distraction. And it is their abiding natures, their willingness to bear our burdens that we learn to step beyond ourselves and, for even a few necessary moments, see the world as they do, as in Sanders's poem "Beatitudes Again: The Horse Lesson, July Nightfall":

Blessed the heaviness they have no choice but carry,
the warm wind washing well away
the nuisance of thought, blessed this nothing that settles
upon our ears, the dust that settles all questions.

Here is the willingness to carry the burdens we are incapable of carrying alone, the horse's simple acceptance that comes to us like grace, along with the quest that settles upon their ears and the hints of mortality in the dust that settles all questions.

Back on the trail at Hell's Gate State Park, I turn my small horse up the switchback trail and head for the utmost ridge with its overview of what is the remnant of a lakebed. Hard to believe now, seeing the soft flow of grasses in wind, the fuzz verge that hugs the hillsides, that this place was forged of violence. The deep canyon with its swale of hills created by the bursting of the great ice dam that released the entirety of Glacial Lake Missoula, a lake over 2000 feet deep and 3000 square miles, 500 cubic miles of water, in one week. Imagine it, a 1000 foot high hill of water bearing its freight of stone, its mountain of mud. One week, in which it must have seemed all the world's water had been loosed to pour down and out across three states, catastrophic in its speed and scope—carving out canyons, gouging out lakes and gorges, channels, trench spurs, cataract cliffs and punch pots. I look over it now, the violence of it glossed over by the ten thousand and more years of healing green, the sedimentary hills softened under the wealth of windblown loess. That is not to say it doesn't have its hazards—the cliff face with its 500 foot drop to the rocks below, the talus slopes and scree with their uncertain footing. But in difficulty it is where my small horse has gifted me with what I thought I had long ago lost. Trust. I must trust him to carry me safely, as he has through the years given trust over to me. In a world in which I am still predator, and the horse is an animal of prey, he has had to overcome his fears as an animal of prey, his mistrust, or ambivalence about having the "enemy" on his back, and instead, he has willingly offered his companionship, taken me into his herd, offered a quiet eye—round and dark—a pliant back and solid footing. And in so doing, it is this small horse who has taught me, yet again:

Trust like giving the horse his head
to feel his way over stony rubble,
perilous going, getting there.
 "On Horseback, Hell's Gate Canyon, October"

Horses demand the best of us, for they reflect who we are. If I lean in the saddle, I must likewise lean to follow the shifting weight. It's about balance. And if I'm frightened, or upset, likewise, intuitive animal that he is, he will cue into that fear and express it for the both of us. But when we understand this dynamic, and thus are made to move beyond mistrust, or beyond the needs of ourselves, when we connect with them in this deeper more meaningful way

it is an entry into a world other than ours. And if we are patient enough, wise enough to attend to them, we are perhaps permitted an insight into what is sacred as shown in the poem "The Horse Considers Hell":

> Prayer is
> heads dropped forward, a back hoof
> lifted in rest, sanctum beneath birch boughs
> where leafy shadows, holy
> and nothing less, wash away summer's rage . . .

I ease the horse off the ridge, down the narrow decline, through a gray wash. At the bottom we dip into a gulley blown full and head-high with tumbleweed, and, good horse that he is, he does not balk nor struggle but wades through the mass. Atop his back I have become his eyes, steer him by leg and voice through the jumble until we reach the far side, and step up and free of the snarl. I lean forward, clap him on the neck, "good boy," I say, and "thank you, little guy," and he tosses his head, and steps forward, proud of himself, his footing, as ever, certain. Like the full journey of horse into this difficult but amazing terrain, Sanders's work *Landscapes, with Horses*, brings us full circle from that first encounter with the horse in a desperate need toward healing, and moves gradually into, not only a measure of healing, but a desire to live more deeply. We discover a world in which we can trust once again, and having come to that place, we are allowed to recognize the hands of grace that carry us beyond our poor limits as humans.

Paired to this lovely collection of poems are the woodcuts of Charles Jones. Just as Sanders expresses the full roundness of a landscape of horses, so Jones gives us the visuals that capture not only the elegance of the animal itself but also the essence of what it is to be *horse*, and the intangibles connected to our understanding of horse. If his woodcut portrait gives us the wildness of the mare in the opening pages, it is his brilliant use of line and contrast in the depictions of the herd that resonate best with the idea of landscape and horse. In concert with the poems "Feeding Horses During Snow" and "In Hurricane, with Horses," the images give us the visual struggle of animal within the elements—slanted lines of weather and braced bone and flesh—the landscape and horse becoming interactive in a clash of black and white. These pieces contrast the quieter portraits, such as the center spread of herd in which the landscape and horses appear to flow in and out of one another emphasizing both the ebb and flow of struggle and emphasizing the insight evidenced in the poems. These woodcuts invite us in, even as the poems do, to explore and more deeply experience what it is the artist and poet see in them, their quiet, the strength, the wildness and community. *Landscapes, with Horses* is a superb collaboration, a melding of poem and image to give the larger story of what it means to step outside of ourselves, and reconnect to the greater world and within.

"Horses make a landscape look more beautiful."
—Alice Walker

Landscapes, with Horses

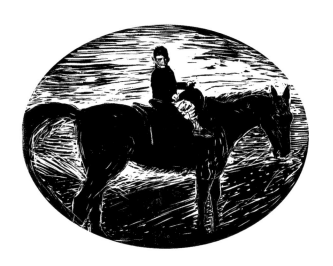

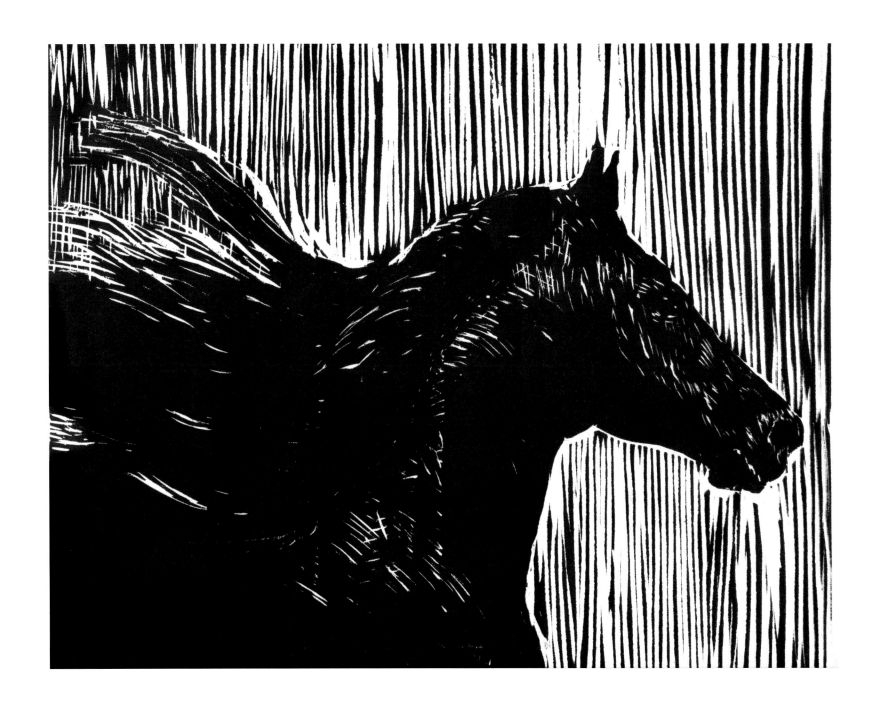

Why We Bought a Horse

for Comet

After our boy died, the black mare
was necessary: bug-eyed, underfed,
ribs like lath. We didn't know
she was dangerous, ears pinned flat
against her head as much a warning

as a red flag on the beach
where Portuguese men-of-war land
their flotilla, the diamondback's rattle,
or the siren's wail as clouds fold
and wind bucks rooftops off.

Necessary thing she was, we didn't know
wildness disapproves halter, lead, longe-line,
the coaxing despite how gentle.
That first time, nylon rope melting calluses,
she reared to strike front hooves down.

I dodged the tumult, tried again, and,
next, was awarded the hip-pivot
to kick. Round and round, the mare
and I danced, one step from disaster,
one slip from what was paramount

for those closest to me, wishing death
upon themselves, desiring dust
beneath the horse's hooves. She
had stood her ground before against others.
Knowing enmity of unwant,

she worked death out of me.
Her stampings my heart's knocking,
her bolting as from invisible fear
my stubborn holding on. I stayed
with her, stayed with her,

stayed with her until she calmed
at my singing, until she plodded behind me,
head down, hooves hoving quietly.
Until, among similar enemies,
wild things made peace.

Mare with Foal

The mare would not be ridden.
She would take the bridle, the blanket, the saddle,
the cinch, the back strap.
She would not take the rider.

Explode. That, she would do.
The fence rail, the ground, took all her weight.
She dared the rider on. Pain was nothing.

Bred, though, her eyes softened.
The hand that scratched her withers, that left its impression
on her back, flank, hip, tummy, teats, she accepted.
She'd follow that touch. Intention was everything.

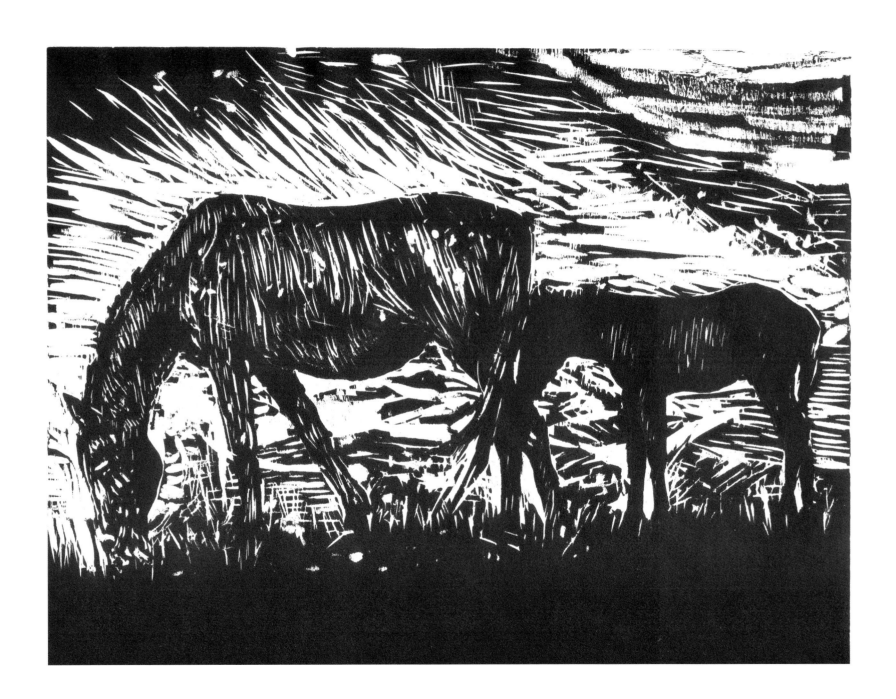

The Idaho Farm, June 2004

for W. K.

Standing out behind our barn,
feeding horses, my wife says,
"This is *our* piece of ground.

This is our piece of ground,
what we worked for, all this dirt
and green, all that sky, all that blue

and green. *That* sky!—all the blues
we can finally let go." She's ecstatic,
though the good news for now

is we can't own the land,
as our old friend says, because it
owns us. The good news for now

is we find our stories in our place,
like horses, feeding, nodding, sustained—
hooves solid where they stand, we stand.

The Horse Knows

the peripheral: a fear—
a sudden leaf, the pheasant jumping with a shriek
from a thistle thicket,
the vine that could be snake.

Shadow the ancient memory
of wolf, bear, cougar.

Rear. Turn. Run. Lift that tail like a flag.
Kick.

*

The girl who rode his back was a pleasure—
she, bearing no weight, was flex of shoulder muscle,
of flank.

She was horse, as he was horse.
When she rode, it was merely the way he galloped.

*

The rain fell all day.
He stood beneath the leafless black oak
and did not regret his predicament.

His bay skin trembled.

A beautiful day to stand, as the oak did,
and shine with wet.

*

How sweet the heads of coneflower.
How sweet the brome.
How sweet to feel firm ground underfoot, dust lifting;
music of chew, rhythm of stomp.

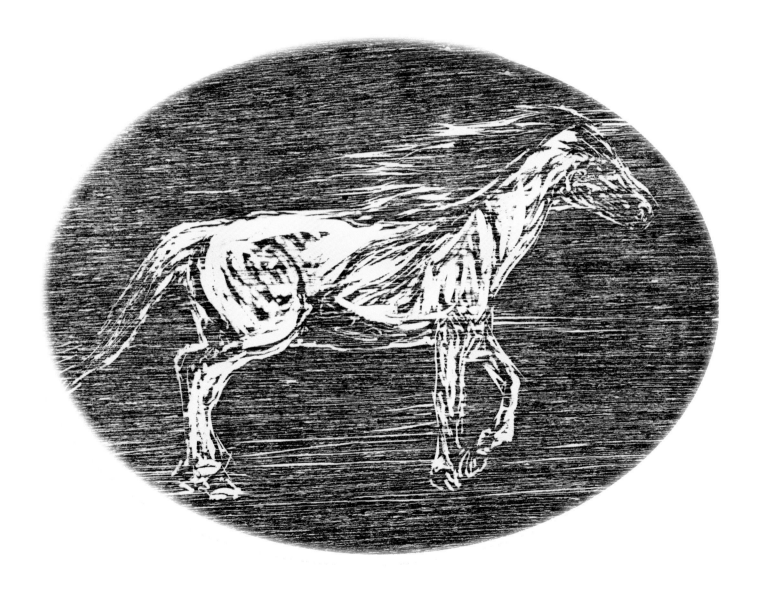

Cold Front, September

Listen: wind lifts leaves from the lawn
and back into the oak limbs they fell from.
A clatter there, as if someone rattled a door to a house
where a neighbor slept deeply the day's doldrums.
Suddenly the astonished mass rushes to rise to answer.

Across the hollow a hound complains,
and others respond until the woods sing the cold, crisp news.
The horses in the pasture, reeling
in the thrill, toss their heads, leap
and run hard on harder ground.

Rain builds far West, clouds black and wrapped in strings of light,
but thunder rumbling here already.

Beatitudes, June Dusk

Blessed is the horse, head bowed, in deep Bermuda,
pond frogs decreeing day's end, egrets lifting
and falling like snow despite the warm breeze.

Blessed are his ears, shifting forward, back,
checking the approach of nothing,
blessed the tail brushing off nuisance,
his eyes, soft as dusk, closing.

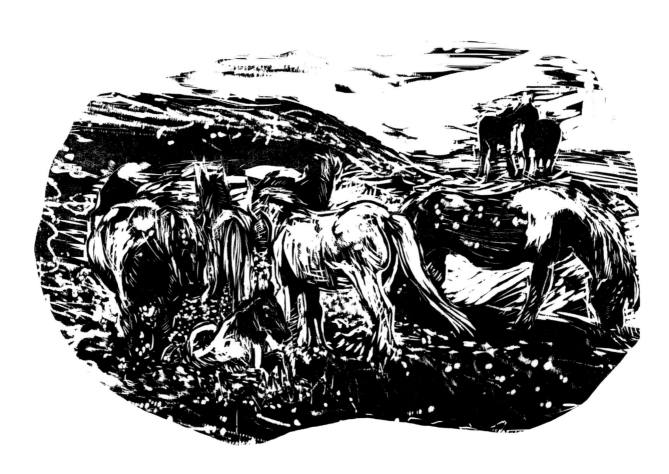

Early Morning on Farm Road

Deer lie down in coastal grass
where horses, knee-deep and dreaming,
stand and nod then face in slow wakefulness
the fog that drifts and blazes with first sun.
Yellow mist, gold haloes crowning oaks and ash.
Barbed-wire strums with whirrings
of wren and finch, such little wheels,
and the country road, under still heavy dew,
lulls like a snake, so chilled it cannot move.

Frost at First Sun

The pasture glazed silver,
horses carry the night's black.

Steam lifts. Hands of ghosts
wash them true and back to color.

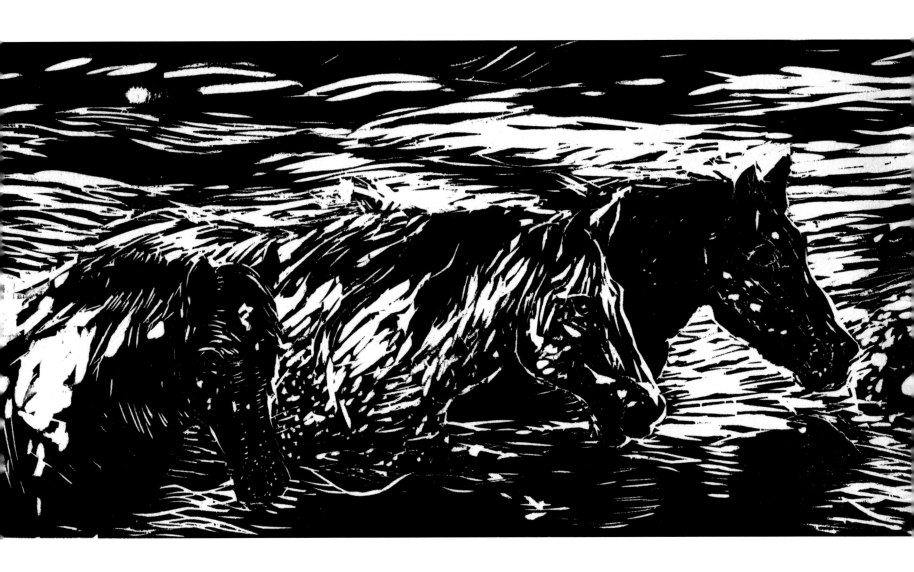

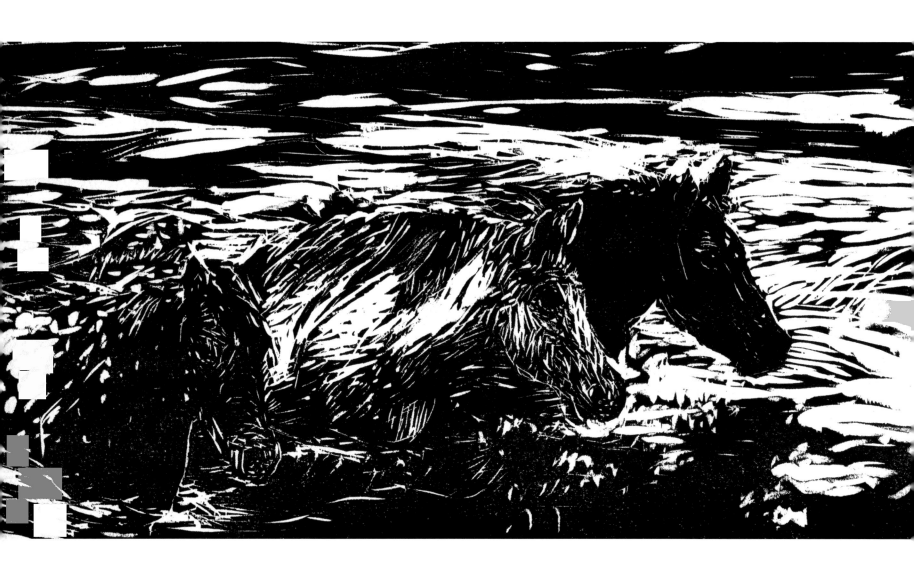

Horses, Considering Winter

Once we stood beneath
bare elm branches
as drizzle fell;
hair, slick, hugged skin and twitched
like wind-teetered leaves.
Wet crawled over us
and seemed gnats.

The night just before ice,
six sets of lights infused
the gravel road, motors
humming, droning, pebbles grinding;
tires slushed slop,
and we heard a softness:
the cavity and the abscess coming.

The lights we dared
be eyes of predators stalking
so we might run, might
fire the furnace that heats
a horse, that it might ease chill.
Sometimes a horse wishes to disappear
in the shadow of rain's shadow,

body's steam like a soul leaving.
Beneath the elms, locked
as we are inside a square,
we might have found death warm.
A miserable time for horses:
November wet,
when it will not yet snow

and ice mats the mane,
hangs in tail-hair. We lower our heads,
abject—stand prayerfully
with half-closed eyes
though horses do not pray—
we understand that as human frailty.
Watch how prayers go for horses.

We shiver, paw, nicker, blow:
it changes nothing.
Who knows as well as horses
that hell is not a place
of heat, where grassfires
burn pastures black?
Nor is it other than where we are now,

this cold, wet place,
this sometimes buried place
when snow finally erases us.
Yet, inside the misery falling
proof of a heaven for horses.
Gospel in rain, the hymn in hoof percussion
as we run the rough range.

As we were meant for.

Meteor Shower, and Horses

I stand in the middle of the horse pasture,
six geldings lolling around me,
the night sky riddled with bullets of light.
> *Look out,* I say, *the stars are falling.*

Horses never look up but stare
at the ground, face assward chilled breezes.
They nod, not in approval, but as
> trees do, in comfort from movement.

I stand in the middle of the horse pasture.
Sweet horse smell, grass and leather, bleeds
like night sky, riddled with bullets of light.
> The stars spin, the horses hover.

Were I the axis of the casual universe,
lord of ground or mood inside chilled breezes,
something not human, I'd do as horses do,
> as trees do, taking comfort in motion

and in the mesmerizing harmony
of six geldings lolling around me,
chords of light streaking the sky.
> *Look out,* I say, *the sky is falling.*

The horses do not look up. They stare
into an emptiness they care nothing about,
nod, not approving, but like
> all angels of the earth, wearing

hooves or standing on two legs.
Quiet giants have nothing to gain in black sky
riddled with bullets of light.
> Let all stars fall, the sky fall

near our faces, what is ahead is ahead.

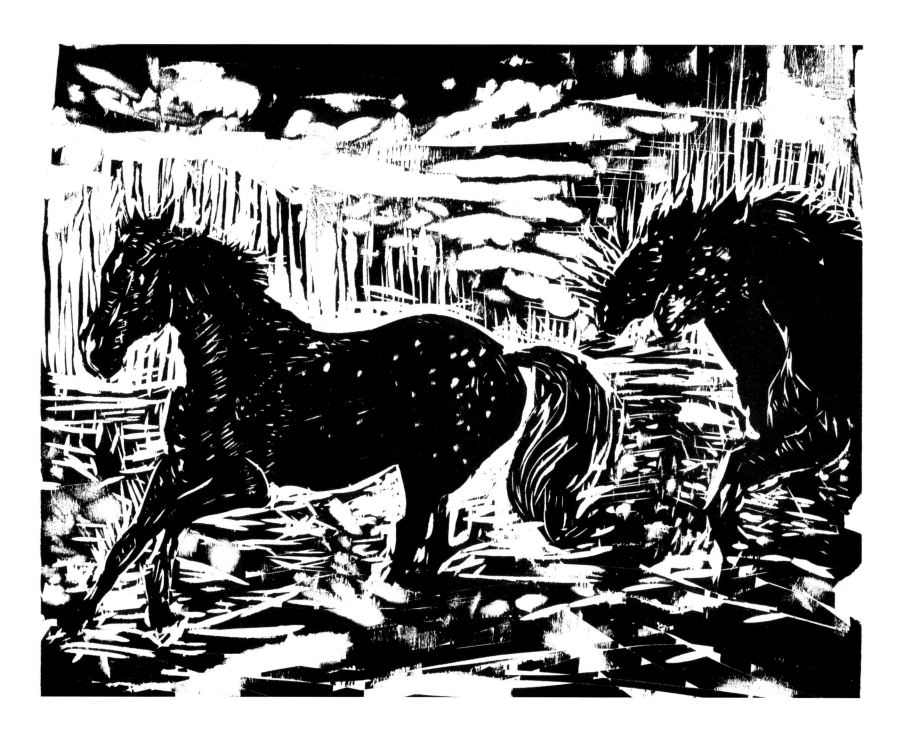

Thunderstorm on Farm Road

I stand at the center of the road the weather paves,
rain like a roller laying flat the county's blacktop,
to once again lead the horses to stall and calm, to abate them
with hay and oats, the sweet and sleepy dust.
Scrub oak and sweet gum, jack pine and locust,
knocked about, bullied, twist and tangle
in the grip and eddy of the air's deepening river.
Limbs crack. Upturned roots rip the weave of red dirt
and Bermuda, tangle of dewberry vine. Best to bend
in drench and chill as you can, like blind Samson groping his way,
lifting to the storm's lift, and, like thunder
and pang of light, groaning from habit as columns of sky fall.

Reparations

I fix five lines of barbed wire
and a post weakened from rot where the mare
knocked through. Cut, flies swarm blood on her ribs,
her thighs, down her legs. She's left a trail
of herself over grass and sand, and,
uncomfortable with sting, paws the ground
and hovers near: how is it I don't fear the claws?

Lucky day: the wire had not caught and, tangled,
tripped her. Rolling as horses panicked do, wrapping
as wire will, it all came apart. She had not
made herself a knot only a bullet could untie.
Imagine the horse: wild still wild inside her,
lions in those brambles, wolves' teeth.
Where she'd let me touch, I've caked a balm.

The breeze, blowing across the east pond,
is luckier and cool. Summer heat, a galvanized coil
to be wound in, invigorates the calm
a man and horse need of each other.
I make reparation, no gloves or sleeves for me:
a scar is a brand I can wear to be like horse.

My hammer works staples into new wood
odorous with creosote, and pliers lever wires
until they sing a silver-tongued harmony
of hooves and hands composed of ache,
barbs like notes on a wire staff, a range
where we might go should we break through.

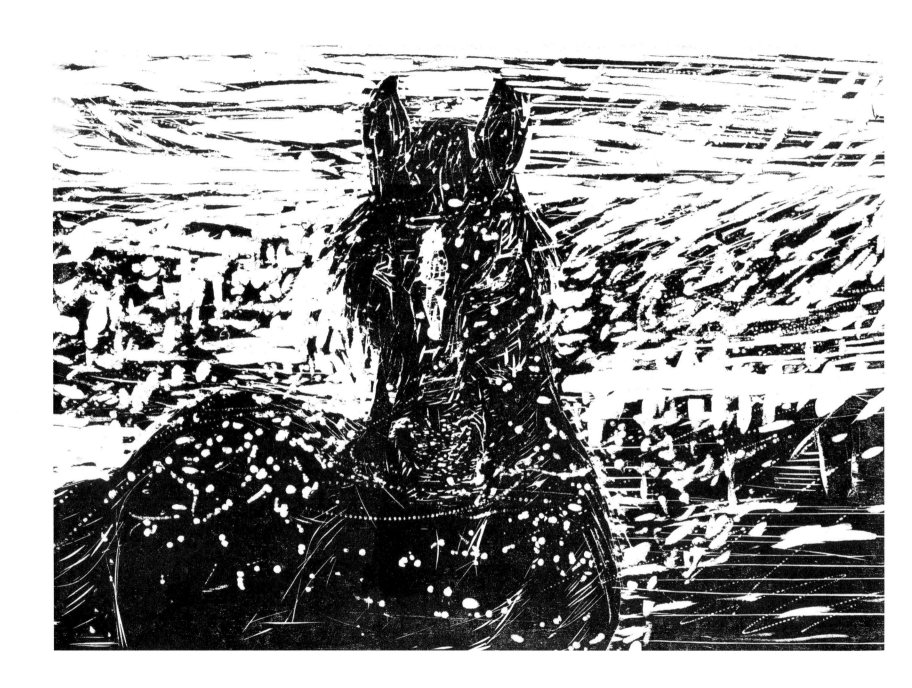

Feeding Horses, During Snow

1

You walk out to the horses, pasture grass glazed,
 ice crunching underfoot, arms loaded with hay.
The horses, cold. Backs and manes draped in white lace,
 they quiver and murmur at a far corner beneath two elms that, leafless,
provide only presence, a recollection of last summer.
 Wind pushes, nudges, spurs. See how it is:
the horses' heads bowed, bottom lips pouting,
 impatient hoof-stomp, neck-sway, the nostril-steam.

2

Snow's haze makes small even largest things: the barn reduced, the trees;
 gray dissolves distance between you and your neighbors.
Stands of aspen, twists of raspberry, a progress of fence rows—all diminish.
 You know yourself as the cold which strides to meet the horses
who, when wind began, danced and tossed their heads,
 farted as they bolted, tails up, feeling good. Now the geldings
are ghosts—you click your tongue to stir them,
 you summon their names loud and prayerfully.

3

This is how it is with them, white weight
 like horse knowledge. When they turn their heads,
nickering and sighing, puffing steam, they don't see you.
 Not hear your boots cutting snow, breaking frozen grass,
not sense the layers that house the unfamiliar animal stalking their way,
 not see your face, not you who blankets, saddles, cinches them,
bits them, rides them, but the hay they want,
 the alfalfa heat, that something necessary and green.

Portraits on the High Terrain

1.

The bay and the sorrel carried riders down a long switchback.
Side by side, heads lifted, dropped,
a constant music, the cadence of hooves.

Palisades of columnar lava and cliffs.
Fescue and thistle, magpies and buntings,
a leafy, stemmy quiet.

The horses understood, unlike the riders,
it was all a part of themselves.

2.

The woman who fed the young paint apple treats
let the horse's lips quiver against her palm.
A closeness that species could share—
morsel, kiss.

3.

Alone in her stall, the mare slept and breathed peace
in talcum of hay and dust,
the snowy country beyond the paddock gentle.

The horse was out of her, galloping
over a knob, down a ridge.

4.

The horse in the trailer saw the blur of long miles,
distant mountains where white pine
stood beneath snow-topped crags,
river sheen, monotony of posts.
Trucks and cars buzzed past. A familiar noise.
The horse flicked its tail to keep flies off.

5.

When the one-eyed dog ran the field,
it ran between the horse's legs.
Catching it, the horse rolled the dog
which yelped and limped after the rider and the horse that hurt it.
The dog knew to keep its distance.

The horse, though, never knew there had been a dog.
It was just one of many clods on a cloudy afternoon.

6.

The man hung to the gelding's neck,
rubbing the black luster, his strong jaw.
The man enjoyed and believed his horse did, too.

The gelding wanted his alfalfa.
He would please the man
and wait longer if he had to.

7.

At first the water was cool to drink,
but the rider urged his horse into the creek.

The horse danced a little, feeling for surety on flat rocks,
light on the water a million fireflies.

Etude for Winter

The black mare wore a shawl of snow.
The snow fell, was going to fall, just as night was obligated.

Bit by bit, the mare disappeared.
White washed over black, black over white.
Only she knew where she was.

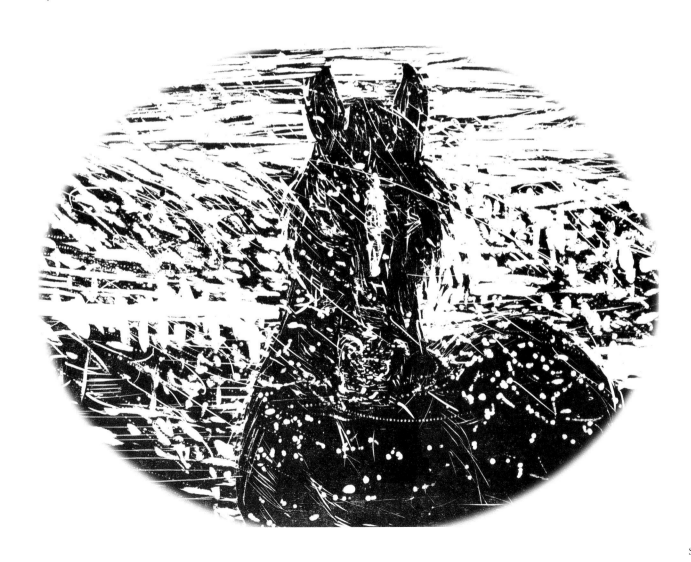

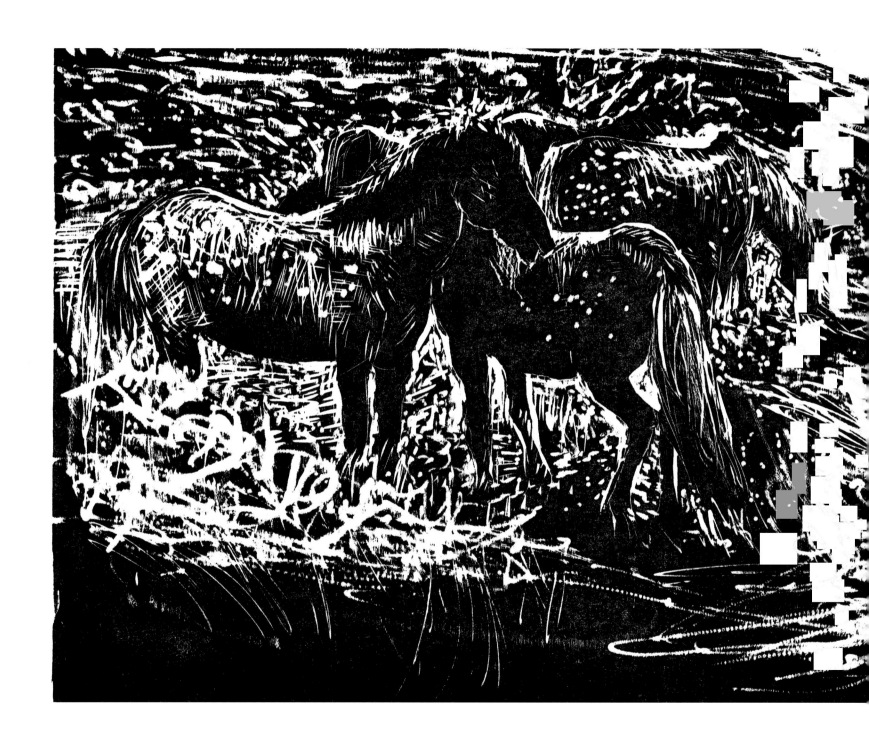

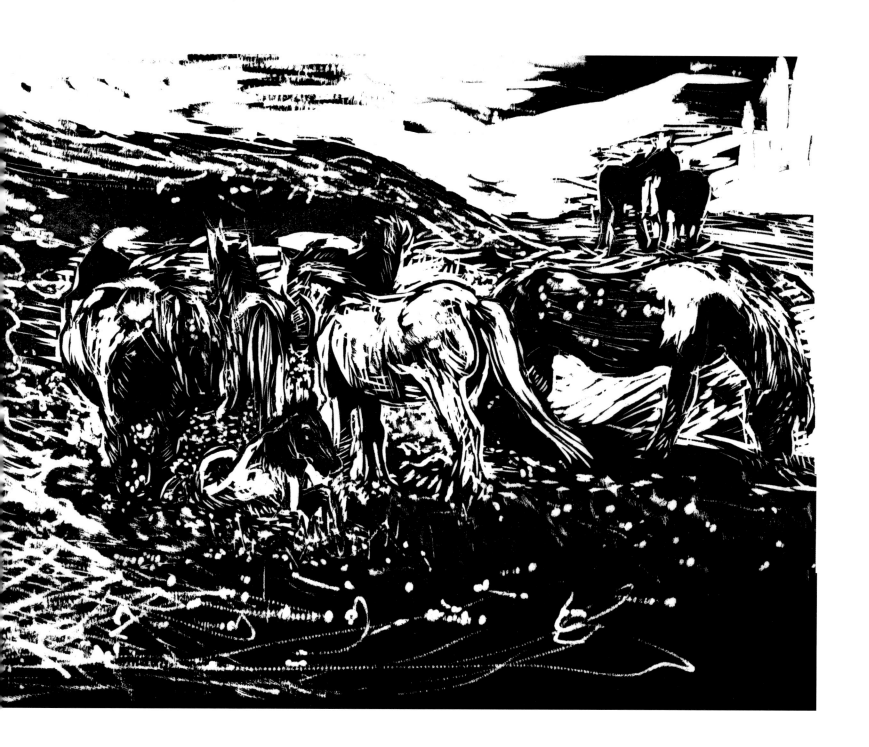

Physics

When birds flew from tufted grass,
the horse jumped,
half turned a circle and bolted
down rock-sided trails.

The birds cut wide, prevailing arcs
over switchbacks
and mudslide scabs.
The rider clung to the saddle horn,

knees locked, feet pressed
to stirrups. Tension ran through rein
to bit while, once calm and inert,
the universe galloped the other way.

Grace, This Spring Morning

The horses nubbed new grass,
eyes soft, the meal meager.
Ears lobbed forward caught, no doubt,
the hum of inferences that could not concern them.
They moved in the singularity of giant patience.

Work to do: last year's squashes
dissolved in the garden, unpicked okra
like horse ears on stalks, spent leaves that required
turning under, disposition of mulch.
A robin sat the fence that needs repair, exclaimed and rose.

The sky sat like a load in the saddle of trees.
The shovel head brayed like a mule.

Counting Horses

One, to see the horses still stand,
wind moving manes or sun tilting morning shadows
onto wires and posts enclosing the pasture;
to have them caught in moment and web,
early hum of birds lifting from oaks.

Two, to find them sound upon hooves,
no mare or gelding limping, not one with colic,
not one crone prone and immovable; but—
nod or toss of head, a foot drumming hard ground;
breath and fart and hack on dust in hay.

Three, because the world we roam is unsound,
storms brewing south and west and north,
daylight diminishing; ascensions and declensions,
switchbacks, and flats where water
cannot stand where it should.

Four, because that's how counting works,
dimes made of our lovelies parceled out,
and deep things, down things,
sweet coins spent and spent again.
The coffee cup cast empty except of need.

Five, because, so long as the horses
are alive, all muscled and beautiful,
what remains fresh and true is grass
blue across morning fields,
things yet as they should be,

perfect, permanent, unretractable.

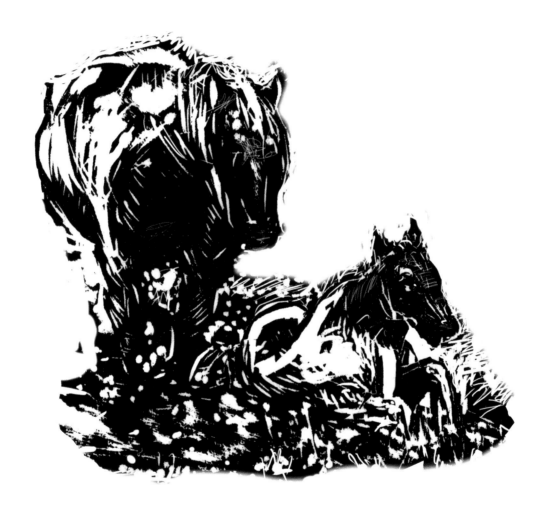

The High Desert, Idaho, Late October

for Kimberly and Claire

The fox watched three on horseback, the long ride
nearing end a half-mile down a shale slope. Powder and sift
muffled clip and clop and gave us this little pleasure:

the fox, red-tail flag, at the foot of a mud-slide knob,
a narrow head of gully washed by water and wind.
He had not run but lifted his wedge-head to stare.

We pulled up reins, halted, and watched him back.
The geldings, smelling what they had not seen,
flexed nostrils, snorted, pawed ground, until leather's slack

moved them and us, and the fox hid in a cheat grass lair.

Longeing

The yearling, driven by a man in a straw Bailey,
rounded the pen until she was breathless, sweaty, greasy.

Her hooves drove up a dust that smelled like her.

She walked, later, halter and lead,
behind the man, her head down.

Worn out, humbled, her spirit still drove dust in the pen.

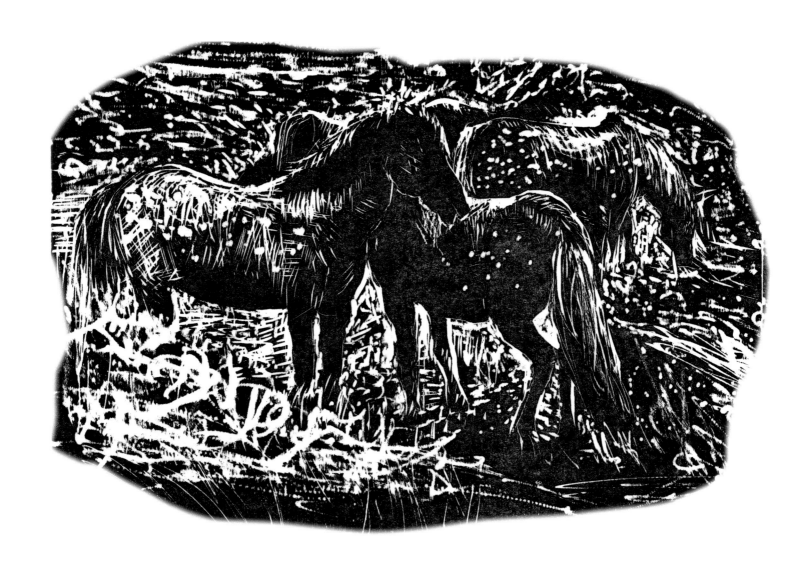

108°—The Horse Pasture

Morning's haze burns deep blue.
The horses, leaving the lean-to's shade,
lumber toward the barn door, hooves
dragging powder, lifting dust, a brown fog.

Hay that is hot is deepest sweet,
and the horses come abject and penitent
through sun's brightness, the pasture
cooked, nubbed to nothing,

toward flakes I toss them. Dull green embers
fly back into my face, light upon my hair
and clothes, and it's hay smoke I inhale,
hay burn I wear. The third week:

dry, high desert, mountain valley choked
on smoke from forest fires up the Clearwater.
All things particled, we breathe and toke
the ash of ourselves. I've come to an hour in life,

a quarter to death, and fever of climate
tells me it's good to languish in thick,
to trod the sift we become. Haze eases
all questions. We graze the furnace

that brazes us, stand immersed in weather
intolerant and bland, ourselves intolerant
and bland, going as horses go, seeking sweetness
and a shade to which we'll return.

Two Choruses, in Which Horses Play a Part

In the morning, there was wind.
The horse's eyes half-closed against it,
the mane, pulled beyond the length of its strands,
the tail that tried to fly.
The horse stood there, as a hawk does, halted on air.

In the afternoon, there was wind.
The eyes half-closed.
The mane pulling, the tail.
The horse there still, the hawk, somewhere, there.

In the night, the wind.
The horse had not moved at all.
The wind and the hawk air took away had a place to get to.
The horse, patient, persistent, did not.

*

Climbing the cow face up the ridge,
the old gray leapt, leapt, leapt.
The hooves dug and kicked down rock.
The sky, cloud-mottled, bright with sun,
waited at the top.

Behind him, down basalt slopes,
a ribbon of river sparkled like shine
on darkest grass.

The curious horse never saw that. On the way down,
he eyed the trail where his feet would land,
the ground more dangerous than sky.

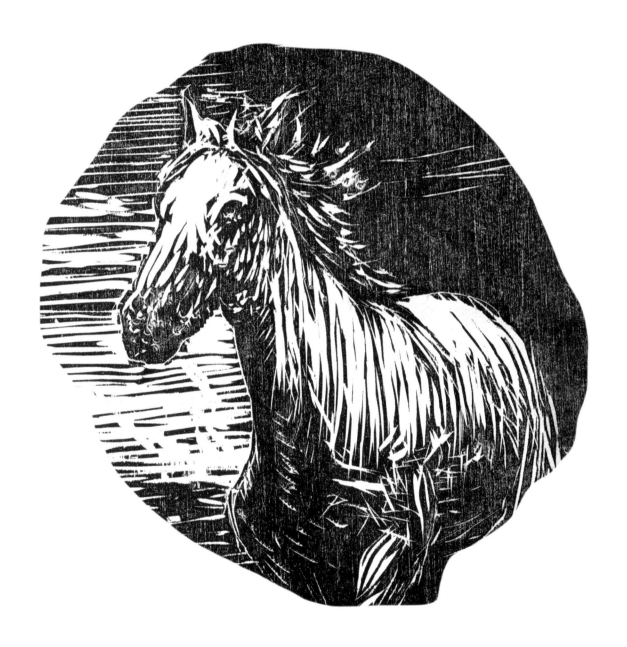

Anecdote of the Horses

I took six horses to Texas,
turned them loose in a pasture
deep blue with coastal grass
filled with wind that bent the reeds.

I turned them from their trailer,
and they ran as herd in a wide wave
like geese that ride winter wind
or a surge that mounts a sandy beach.

They encompassed all that new space,
hooves rumbling like breakers,
the curving ebb of drawn-in tide.
But nothing like any water in Texas.

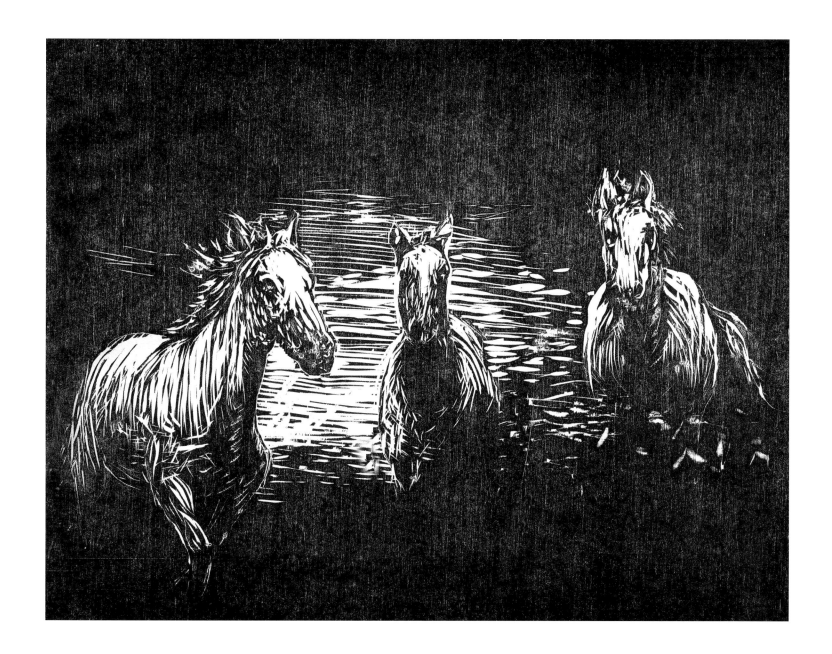

In Hurricane, with Horses

The man, gray-flannel shirt lifted overhead
shielding him, strides long, alone in the blow—north
then south, cold then hot. Who would think
to count the rain, weightless, infinite, like slivers.

He yells and whistles silence against the howl
at six horses hunkered under oaks at pasture's end.
All around, the woods groan, their bones pop.
The sky churns blackening butter.

Waist-deep grass underfoot rolls flat
as by waves upon a long shore. A loblolly pine
collapses, its root ball like a molar;
a wire tangle blossoms barb and spark.

The horses circle upon the circle of themselves.
He stands at their nervous center, an eye. Easy now,
he coos, and slips the halter upon the oldest head,
the one to lead the rest to shelter.

Now unhurried nudge through rivers in air,
as in the plodding cadence of the high terrain,
the rocky switchback. Pitch and plunge
looming above them, clouds like cliffs ascend.

Across Farm Road

At the neighbor's pond, kids near pickups
holler, skipping stones across the calm.
My horses watch, wait, and worry,
ears lobbed forward, instinct a pulse
in legs, shoulders, flanks, a bolt to open meadows
or steep inclines a predator could not comfortably crawl,
shale on slopes, cascades of stone to bring a charge quiet.
Here, inside perimeters of post and wire,
flat blue-green pasture, no haven
save shady trees or lean-tos to shield them.
My horses stare, and I join, watching what they worry over.
Noise skips and sinks into the tubs of our ears.
We stand our furious ground.

The Horse Considers Hell

Not heat nor flame, but blacktop drone—
trailer tires and endless miles,
wind whistling tenor madness, rain
pouring in, the pooling mist
that blooms upward from behind the truck.

In long night dreams, we might ascend
a switchback, endure a saddle
and the labor that sits there, top a slope
and see the valley unfurl, breezy slip
of creek or river; might run a pasture,
spin, buck, fart, or stand beneath
a slanted roof as sleet bullets.
 Prayer is
heads dropped forward, a back hoof
lifted in rest, sanctum beneath birch boughs
where leafy shadows, holy
and nothing less, wash away summer's rage.
This: how to go.

But tied and haltered, paneled off,
the haul unending, long heat, longer cold.
It is the heaviness we bear upon our hooves
and the heaviness we bear upon our hooves.

Drought

Far West, past pine woods that crawl the hill
like prospectors in a desert, the bottoms
where the creek has run dry and the gold ground
creases like an old man's skin, thunder mumbles
the sky's unspoken thought.
 At the fence's edge,
horses nudge the ground where they have spread flat
bales of hay trucked in across five states.
I see dollars lift from the August brown, embers and ash,
and somewhere, I can smell it, smoke rides the air.

I will the clouds to come home, here, to stir things
as a rainmaker might, alert the trees, anxious or dying—old crones
who, when if they danced, break bones and tumble.
I'd bring the news to the old boys shining in the woods,
the coyotes and big cats who, under the moon's eye,

trouble the neighbor's bawling stock. Music is afoot,
but I'm a wallflower who can't initiate a step,
and thunder may be little more than noise before steeping silence,
a mirage of green and grass and damp and hope precipitating
not a last waltz but no waltz at all, this our stake in the matter.

A Thousand Reasons

After rain, day's end, steam rises
from the pasture, coastal hay summer brittle.
Fog sits on the cool green of loblolly pine
and white oak. Egrets at a pond's edge
at the edge of sight lift and float away.
Twilight darkens.
 The old horse, retired,
sullen and wet, stands the ground
that one day will stand him.
What is there not to love?
Frogs and toads switch on, and—
there they are as if the first stars—
the fireflies revolving around him,
the universe's center still unspooling.

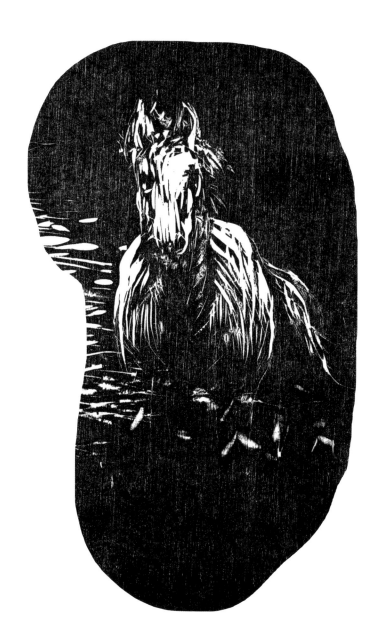

The Ghosts on Farm Road

Steam lifts off the stock pond, and,
though I don't know why they are there,
the dead have come again to bother me.
The horses, who bump the fence, impatient,
do not see them, do not care the dead are there—
what might the dead do? Stop the sun?
The horses paw the feedlot dust and snort,
whatever, whatever.
 Yet—
the wisp that dances most wildly
is the sister whose health would not permit dance
in the first place; no wind this morning—
the intimate absence of breath she knew.
There her ghost is, skating and twirling.
And there my father, hunkered to the water,
too heavy to move, big man bearing the burden
of his bulk upon the bulk he had been handed.
My mother, too, between the two, there, thin
and aspiring skyward into the nothing
they all became. Puffs of steam mouthed in cold.

Once—how long has it been?—I had ridden horses up
switchbacks in rocky terrain, kneeing them onward,
posting in the saddle to lessen the jolt the ride made.
In those days the dead hid behind stones big as houses,
big as grief, trees black and contorted as from nightmares;
they moved inside clouds that streamed in rivers above the river.
I feared the ghosts would spook the horses,
but they trod, trod on, and the rocks they kicked down
tilted the balance of sloping daylight until,
now, in current darkness, they are here,
having found me again at last.

Good morning, good morning, *whatever*,
you troublers, hitch and hassle and snag.
The horses need me now. I have work, always work.
See me roll my sleeves. Now stand back.
Let me get on with it.

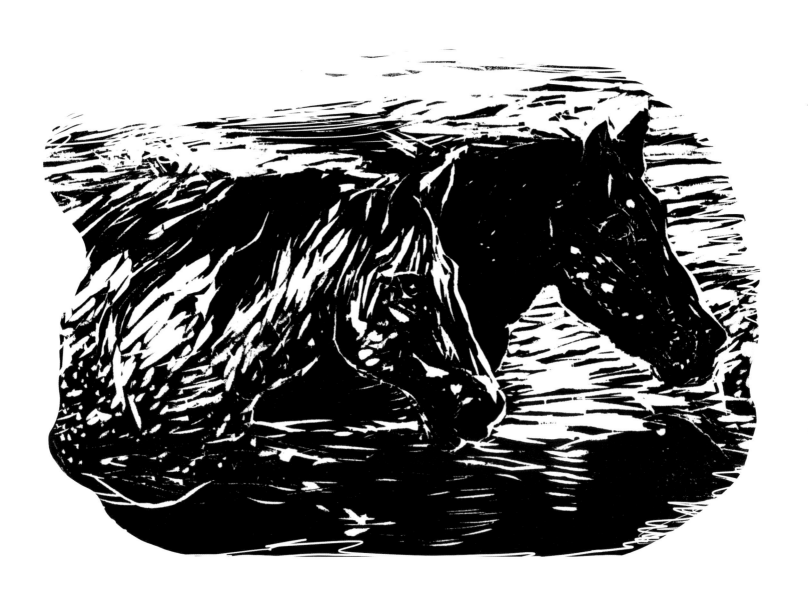

Jed, Last February

The horse will not walk or stand but drops
to his knees, his great bulk going down
slowly, a heavy window swelled in its old frame.
I do what I can to keep the air, cold as it is, moving,
but the house he is, room by room, shuts itself up,
then tumbles over like an antique mattress bound in a roll
by one thin shoestring cut.
 Damp grass where he lies
slips upward through winter mud, so many little promises
crushed. Clouds course his eyes, and—what is there to do but listen?
Breath, in and out, slower and
more slowly, like an old horse itself
knelt to the one intractable faith that will hold him.

Old Wives' Tale

November and a full moon encircled
by a green ring: sure sign of rain
in three days or, if the cold front swaggers
through this door of weather, ice or snow.

Expect shine of eyes in the yaupon thicket,
deer or coon or the ghosts of kin.
Listen for the caterwaul of bobcat
or panther's howl in the deep piney woods,

sung like real blues by the old widow who,
God knows how many generations,
knells the dead her way.
She's at the ring's edge, stirring the pot

that conjures the future, gathers souls
like ripe berries in wicker covered over in flannel,
then ladles them into a bitter syrup
you pour upon your breakfast to last your day.

Everyone knows it is not rain
nor the circle the dead ring around the living
but faith the tradition will stand
that we make of living and loving.

It is the message she sings on the sky:
It is a horse, black like the sun,
its blaze doused in tears.
It is best to hear the news, so she sings:

It is a horse, calm like rock.
The rain will be the river's source.

The rain will slide from the rock and run.
What river do you feed?

What sky weeps for you?
What is the tub you wash your hands and face in?
The old woman sends us to sleep,
this her prayer:

There is a drop of my blood
in your morning's coffee. Drink.
You must cherish me always
if the rain will come. Drink.

The green ring spins about the moon,
horse in a round pen, the moon
a man long dead with a longe line
and a whip driving it like a clock.

The sky, for all the ice glittering,
is dust and seconds falling away.
The conjurer beats a percussion
and wears a cloak of thunder.

Plain Sense

. . . all this
Had to be imagined as an inevitable knowledge,
Required, as a necessity requires.
—Wallace Stevens, "The Plain Sense of Things"

Plain speech for a plain people:
weather-words gray as old lumber;
old sheds and old houses
sitting on the tilted legs of wind;

verbs the cranes dancing, the snow geese dangling,
something wild dashed
into wilder brush or wood, the slow steady plow
of an idea through black dirt, the blossom.

We drive the long, sleepy phrases, and
turn sharp on a country thought;
the gravel punctuates, the noun-heart steers.
A sentence like a pivot: the steel spans circle;

the cold spray a nourishment, a continued green.

*

Two ways of looking at things:

Rain falling into your face from a black sky.
Or, the head turned toward the ground,
the face blurred in the puddle where rain drops.

In the snow funnel, walking blindly through the white of it,
frost in the beard, sweet moist on cold lips.
Or, still: an iced pond, a silver slip of creek.

The mouse in the alfalfa, the hawk's black eye.
Or: the turn, the absolute fall.
The beak, the flesh, the stone talons.

The ground, too, like stone.
Or, the mud temptation.
Or, the porous dark, the quilted bed, the dormant seed.

*

A man wears a sandstone face.
Call it character.
Call it erosion.
The deep cut, the gradual smoothing, the permanence.

*

Every which way the wind:
the cattle-clouds, the skiff-snakes, the gnat-dust;
the dead dressed in green robes swaying, breathing, amorous.

*

Old men passed us bottles of home-brew and we drank.
The taste bitter, the spillage dripping from the spigots of our faces.
The bitterness we recall as sweet: it was cold and wet on a parched day.

Old women poured us coffee from granite-wear pots.
Bavarian china chipped or cracked: chapped lips against our lips.
The hot potion we sweetened, clouded with cream or sipped straight and black.
The house was a mood: damask, vinegar, alum, dust.

*

The swallow is a question mark, the fence posts exclamations.
The elliptical miles, the emphatic cottonwoods.

*

Today, the tasseled breasts of corn, the bearded milo.
The wheat ambles and jigs; the alfalfa swims nude in a blue-green pond.
How can you doubt the optimism of hail, tornado, drought?

*

A child toes the dust and sees creation.
Someone dead smiles in the cloud.

A child picks up a stone and skims the water top.
More pleasure in plunking it to the depths.

A child dismembers a grasshopper.
Later, he puts it back together to dismember it again.

*

The metaphor went around the property.
Meshed, electric, paneled, barbed.

It sectioned the place like a quilt.
It linked.

The cattle did not wander, the calves bawled and sucked.
Pigs squealed and the feeders banged.
The horses ran or lulled about, nodding.

It made the garden secure.

The city folk who came out to sell us something

had to stop at the gate where a big dog stood, growling,
baring its teeth.

*

At the center of it all, a horse stood,
and all that territory around him,
ebbing from flat to hill, creek to river,
was analogous to how the sky sat a saddle.

This is the moral in how to ride—
the sky in tall hat wears an embroidered shirt of cloud and light.

*

A young woman once sat in a pickup truck
high atop a country hill, the hot then cold wind
blowing through open windows, her hair streaming her face,
the black clouds on the night sky
defining blackness.

The music was what she loved: the wind-moan,
the sky-sigh heavy, the cloud heart-knock.
The truck waltzed on its tires.

And best, most best: the sharp light like nerve-something, *yes*,
and, *yes, yes,* the thunder.

*

A plain word is a simple tool.
A nut tightened on its bolt,
the pieces holding.

*

The bull snake crawling on the blacktop
is exact.

The vapor, a heat-thing that crawls and disappears,
is exact.

The meadowlark, perched on a fencepost,
singing, is exact.

And when it flies away, and yet you hear the song,
and feel the heat coil or fly about you,
this is exact, too.

*

It has to have a certain flatness,
like old folks talking on a porch swing
under the bright bulbs of stars,
the electric buzz of cicadas, a chain creaking.
Soft words like the long smoke of a good cigar.

It has to be an observable silence, each spoken stone
compelling,
a flint,
or the snarl of a black cloud-wall just before the point is made.

*

Our eyes hold the almighty sky in callused hands.
Our ears sip deep the odorous blue.

*

The swirl of leaves
is the rattle of brown bones down casket roads.

The swirl of geese and crane,
their bell-gongs,
is trinity: birth, covenant, everlasting.

*

An old farmer danced a polka with a pump handle.
All the old and young cows cried as the music poured.

He switched partners, holding hands with a hay hook,
swinging bales, the dust kicking its heels.

All day like this: everything a tune, everything a dance.
Even as he slept, there was a rhythm to it.

*

There must be a recognition of need,
and need is the plain sense of things near.

*

Out here, water is the great wheel turning.
Listen to the gurgling gears of pond, creek, river.

Out here, we stand at the center of the great wheel,
and we are the ponds, the creeks, the rivers.

So long as there is water, the necessary machine runs.

*

Elemental odes are sounded
on the wings of crane and geese,
the cattle's lowing, the lilt of landscape.

Where the roving sun
is the horse galloping from predatory night.

*

Were the weather any different,
it would not be ours.

Neither the land, how it lifts and falls,
the way a finch dips
or the steep to which the hawk glides
or the depths to which it plunges.
The burdens, the joys, the loves, the broken things:
they would not be ours if they were different.

Anything else and we should destroy the essential:
the gopher-intelligence, the ground muscle,
the harvest-soul.

What is here is ours.
What is here suffices.

Checking Fence, Autumn Chore

I walk the property perimeter, checking posts,
clips and staples that hold wires certain,
to keep horses where they are, not on the highway
where buses and oil trucks grumble blindly along,
not across the farm road in the neighbor's alfalfa
laid low in breeze, the field like an old man napping,
but here, at home, wind in oaks, wind herding clouds,
wood smoke on the wind. Having no use for handwork,
my horses stand at the pasture's center pondering wind.
What motion I make, less than wind, less than the horses themselves,
less than consideration, is a hum their tails sweep away.

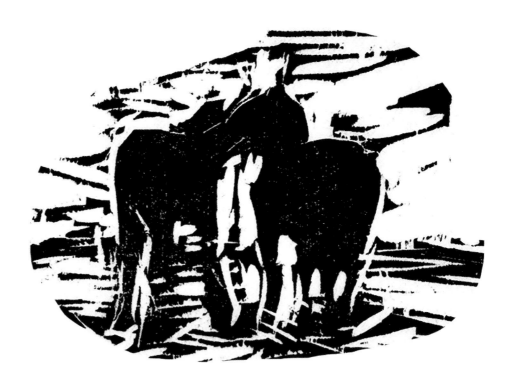

The Messiah Horse

stands at the hitch awaiting the rider, his back bearing
the burden like a bundle packed with old tools—
shovels and picks, gunny sacks for the rock, axes to grind—
all the tarnished gold. See how he carries the load,
at walk or trot, at full gallop as in a rodeo run.
See the rider, old and broken and hardly mended,
hung in the saddle, clumsy and terrified,
boots in stirrups, knees pressed to the fenders, fancy hat
flown off his head. The next fall that might come—
in sand or on rocks, tall grass mashed down—
may be the one that at last lobs him lost.
Black horse solid of the heart, black horse in mind,
black horse of all horses, of all riders, take me to tall places
on rocky switchbacks where heaven, among white pine,
still a prospect, is touchable.

Song in July

Rain's passed over, crickets come from the garden's underside,
wood bark and lantana, turk's caps and bottle brush,
out to the drive to warm, and the dogs,
full of the night's elixir—the damp, the dark,
the dull sheen of yard light laying white
upon the grass—jump after the crickets
as they leap.
 Out of the pasture's steam, a lake in air,
step the horses to the fence, sweat and mud,
a motion and mood and delight.
Here, at this moment, with dogs and crickets,
horses fresh from the grave that could not contain them,
leaps this old heart, who knows how often it may yet feel this way.

Beatitudes, Again:
The Horse Lesson, July Nightfall

Blessed is the man, his head bowed now
in the manner of his horses, standing in blue grass
among quiet giants, listening to pond frogs,
cicadas, the distant thunder that hums in heat.

Blessed the heaviness they have no choice but carry,
the warm wind washing well away
the nuisance of thought; blessed the nothing that settles
upon their ears, the dust that settles all questions,

the oncoming dark, pierced by so many stars,
like doubt turned to grace.

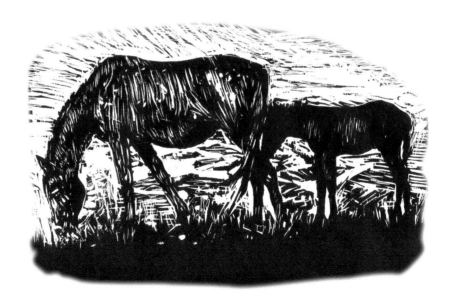

The Horse as the Letter L

for Kimberly

Love moves like something righteous and eternal
enveloped in summer's blanche, air crackling
once sun recedes, and the sky ribboned
is a window pane a shot has pierced, the hole
the horse, that perfect circle of animal fenced by lightning
and the pasture is the thunder of ordinances that summon rain.

Love is that patient creature, wind tearing the mane
and tail, crepe fabric, and the strands are motion and evidence
the foundation and fortress of flesh stands firm.
 Let dirt or sleet welt the horse,
it does not imagine other places, the high spot where a river valley winds
through blind cliffs nor deep wet meadows where it wades,
nor does it remember shale slipping along slopes, when last it fell

and had to lift its bulk, the bit pinching its mouth. It looks forward, always,
at the grass before it, toward the noise it may hear.
It will carry the burden, the clumsy rider; it will trod
warily the stony switchback or woods where what is wild hides
and waits, cleave the tall thick, breeze-bent reeds
as if parting a creek's current.
 Let there always be a horse
to clarify the landscape of love, being what it is and nothing more,
true as oak, true as birds that lift and fall and sing
the one song they know by rote, it does not need to be pronounced
but is.

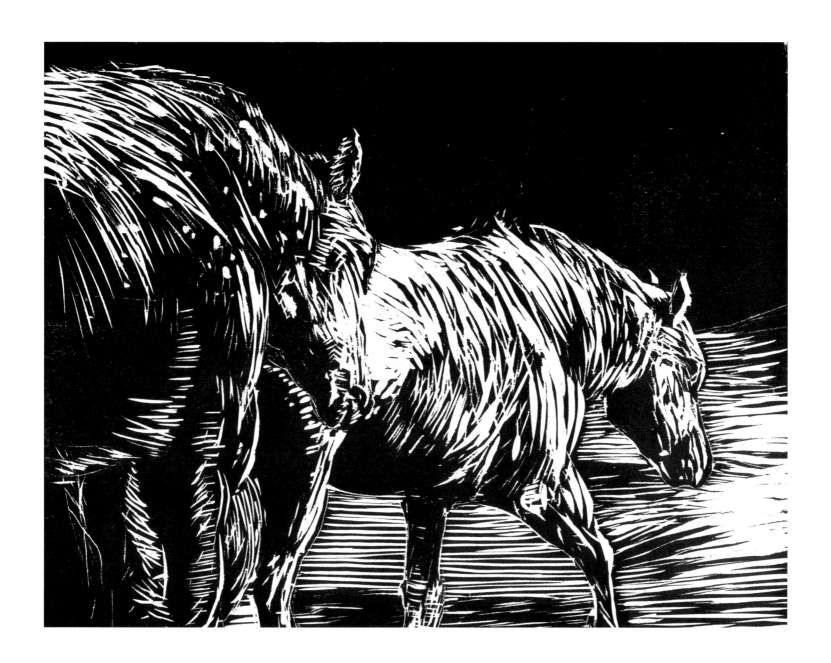

On Horseback,
Hell's Gate Canyon, October

for Kimberly

We ride past basalt columns, ascend
a cow face to top an outcropping
above the Snake and sit there, and watch.

Here is the topography of desire: a sky heavy
with grey smoke, the blue and ancient river,
unrequited; the rogue, stiff bunch

of thistle and sage, brown, curled coneflowers,
and across the stream the accumulated green.
All those oppositions that pull toward a center.

Like the pleated hills of the canyon, distance
pushes away, pushes past an irreparable edge.
Yet here we are, two long-time lovers on horseback,

relics to a belief, putting the pieces together
that creation could not. Constancy a thing
like a slow horse plodding along the veins

that bighorn and cattle cut through rock.
Trust like giving the horse his head
to feel his way over stony rubble,

perilous going, getting there.

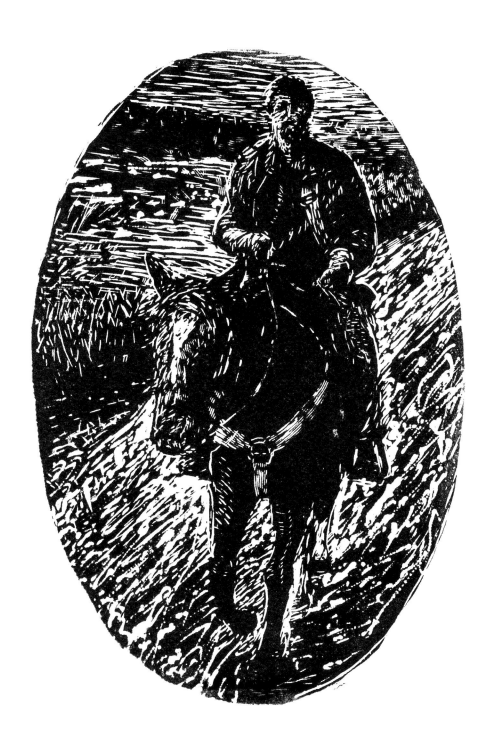

NOTES ON THE MAKING OF *LANDSCAPES, WITH HORSES*

artist's statement by Charles D. Jones

Mark Sanders sent me [his horse] poems shortly after we met. He had become familiar with my woodcuts and fine press books and thought we might collaborate on a project. I was excited about the proposal and started sketching out ideas about what such a work might look like.

I made a mockup and chose a paper and typeface that would match the content and accept the ink from the woodblocks nicely. During the following year, I created an image and cut a block for each of the poems. The type and blocks were then printed and bound in a small edition, as I wanted to combine a portfolio of prints from the wood blocks along with a bound volume of poems and images together in a clam shell box.

It is with pleasure that the work is being printed in a larger trade edition that allows a greater audience, because I believe that the work we have created is a well-balanced synthesis of form and content that brings his words and my woodcut images into a meaningful whole. I believe the work has great resonance because of this.

When I add images to a text, I don't think about making an illustration of the words' content, but more the way a musician thinks of playing a duet as opposed to an accompaniment. I, therefore, have to have a basic understanding of the content expressed in the writing. I relished the idea of working with the poignant expression Mark had written about horses and their relationship to him, his wife Kimberly Verhines, and family and friends, as a theme for a series of woodcuts. I also have had a meaningful relationship to these animals.

Horses were an integral part of my life from an early age. My earliest memories include horses. In the time and place where I grew up, horses were a constant fact of life. Horses were used for transportation, to ride, to pull wagons or slides, or teamed to plow. The three businesses in my home town, Dodge, Texas, all had platforms extending from the rear of their buildings that were wagon-bed high so bags of feed could be easily loaded. My uncle Zane would occasionally entertain with his horse "Silver," who could count on cue, and rare up and walk some distance on his hind legs. When the REA finally brought electricity into East Texas during the mid-1950s, horses, mules, donkeys, and occasionally oxen, were still being used.

When my parents decided to move the family closer to Huntsville, my Dad rode our mare Fly across 15 miles of woods using dead reckoning to arrive in the back yard of an uncle that lived near our new home-place. "Fly" was descended from a stallion reputed to have come from Kentucky racing stock. The story was that one of my great-uncles had gone to Kentucky and bought a horse, from whose blood-line my horse Fly had come. She was called Fly because she loved to run and would "fly" up and down her pasture from the time she could walk.

Soon after coming to our new place, she foaled and had a strongly marked red and white colt. I have strong memories about that mare and her pinto colt. One of the reasons I was intrigued with the challenge of creating a book with images of horses was my relationship with them and their tragic deaths. I based the frontispiece of the book on a photograph of me on our black mare, Fly, and the double-spread on pintos.

I would spend part of each day in the pasture following the mare and colt. At that time, I was seven years old and the pinto colt no more than six months. One day they were gone. I asked my dad where they were, but he would never give me a definite answer. He said that maybe a deer hunter had shot them. Later, near the end of my father's life, he told me that a neighbor's horse, another pinto called Clipper, had killed the colt and that Fly was so distraught she had jumped the fence and been killed on the highway. We shared pastures with this neighbor and knew Clipper as a mean horse who wore a cuff with a drag chain because he would chase and try to hurt the cows. He had evidently attacked and killed the colt. That is why I put her image in the book. My feelings for these animals were a definite inspiration when creating the images.

As I grew up we had other horses that we rode to play "cowboys and Indians" and I came to know their anatomy well, mounting and riding bareback, no shoes and just a cotton rope as a bridle. I also had the duty to harness our ginny donkey to a slide that carried a 55 gallon water barrel and haul water from a spring about a mile away. I continued to ride horses well into adulthood.

The method I use to create is to make a series of drawings while under the influence of the text. I carry a sense of the content without really "thinking" about it. I allow intuition to guide and influence choices throughout the process, in composition, as well as for materials and the tools I use. What I draw, and how, and with what, have a role in the creation. The drawing is blocked in on the wood block with pencil and then it is completed with brush and ink. The composition is checked in a mirror as the final print will be in reverse of the block. The choice of the wood, the dominance and direction of its grain, the tools I use in cutting, and finally the ink and paper choices used to print all contribute to the look or voice of the final image.

The cutting of the block then proceeds, still with the sense of content playing a role in guiding the process. Creating a woodcut involves cutting away that part of a wooden board that is to not receive ink from a brayer and therefore leaving the color of the paper after an impression is made. This is usually white but could be a previously printed color. Any value of grey perceived in a black and white image is optical and created by a texture of black marks, like a half-tone screen. The nature of the woodcut or relief print is an image that is strong in contrast, and one in which the materials used have a strong part to play. That is why I think of my woodcuts as being duets with the wood, and then perhaps a trio with the poems.

BRINGING THE HERD TOGETHER

author's statement by Mark Sanders

When I arrived at Nacogdoches and SFASU in July 2008, I discovered the university had a fine press—LaNana Creek Press—guided by Charlie Jones; I made it a point to meet him and did so within the first few days of coming to my new campus. I had just left Idaho and some of the most beautiful horse country one can find to return to Texas after a many year absence. My wife Kimberly had remained behind temporarily to finalize the sale of our turn-of-the-century home, new on the real estate market, and to take care of the horses which, once we settled business there and here, would come to Texas with us. I truly had no idea what to expect from Charlie or from his printing studio but, once seen, found amazing. Each volume was a work of unexpected art and vision, marriages of word and image hand-sewn, bound, and encased is oversized clamshell cases. I was impressed and immediately imagined potential projects—not for me but for poets whose work I valued and to whom I hoped to introduce Charlie. I hadn't planned, initially, on giving him a manuscript, but our conversations turned that direction. By December 2008, I provided him the core of what would eventually become the fine press edition of *Landscapes, with Horses*. This work has been revised, once again, and become the honed and fuller volume here.

The closest I had ever come to a collaboration such as this was when Harry Duncan printed my little book, *The Suicide*, in 1988 on his Cummington Press imprint, or when his apprentice Denise Brady produced an oversized broadside of my poem, "The Brain-Eaters." Harry's work, which put me into the bibliographic company of Wallace Stevens, William Carlos Williams, and Robert Lowell, was all letterpress, sans the woodcuts that make this book so beautiful. Denise's broadside, way back in 2003, created in me a hunger for this bigger, more generous work—a work I never anticipated nor believed would ever happen. Charlie poured hours of affectionate effort into his edition of *Landscapes*, something I haven't words enough to thank him for.

The horse poems are special to me, in ways most of my poems are not. I was not raised around horses, though I had admired them from safe distance at the county fair when I was a child. I was a town kid surrounded by country—Nebraska farmland and the Sandhills; as much as my father had wanted to be a farmer with all sorts of stock and animals, he never achieved his dream beyond the little chicken coop, full of bantams, he had in his backyard. Horses came to me late in life, in 2002, first one and then another until we had six: Comet, Bart, Lola, Bobbie, Jed, Rusty. Kimberly and I found refuge in the horses; we needed that safe place because it was what spared us. When we moved to Idaho, the horses went with us, and because of those horses we made lasting, permanent friendships and we came to terms, heavily negotiated, with life. We healed, and we healed some more. We rode through Hell's Gate Canyon, and the namesake resonated for me. We had been through hell, and the horses carried us faithfully, trusting us to trust them. We rode 1000 foot switchbacks, sat atop bluffs with sheer cliffs above the Snake River, and our darkness switched back to oppositional light.

What I found in horses was the voice to speak to topics closest my heart and soul. I have often said I know more about people now that I've been around horses; they have made me a quieter, more patient man, and they have provided me a reserve and resilience I hope may transform into a long life, plodding as I might—as a horse might—from one terrain to another, however smooth or rocky. I think horses may be the best kind of people. They carry me, metaphorically, when I haven't spirit enough to carry myself. Close to the earth, their faces in the depths of grass and their ears attentive to motions around them, they have reconnected me to the landscapes I could hardly see any longer, blind man I had become due the hurt and nonsense of living.

What I hope *Landscapes, with Horses* accomplishes for readers is that it connects them to needful territory where love persists, where life persists on the cliff's edge and there's no fear of falling. The giants of the earth that horses are abide in the sort of quiet in which we should all live. Those best people, horses, show me how to be quiet, how to use my fear to survive, how to listen, how to shake off the rains and snows. They dance when they want to, taking pleasure from the cool in the air that lifts them off their hooves; they let the sun wash over them, and stand silent on a ground that for all the infirmity of the world is sure underfoot. They do so without being self-conscious. Where they stand, how they stand, bearing the load they bear of themselves and of what they carry, is not such a bad place or way to be.

Acknowledgments:

Most of these poems were previously published, some in much earlier versions. Much appreciation is extended to the editors and publishers who found value in them, particularly R. T. Smith, Suzan Jantz, Charles D. Jones, Steven Meats, and Kimberly Verhines.

"Why We Bought a Horse," "Feeding Horses, During Snow," and "On Horseback, Hell's Gate Canyon, October" appeared in *Cadence of Hooves: A Celebration of Horses*, edited by Suzan Jantz (Yarroway Mountain Press, 2008).

"The High Desert, Idaho, Late October," "Reparations," "Physics," "Two Choruses, in Which Horses Play a Part," "The Idaho Farm, June 2004," "Mare with Foal," "Cold Front, September," "Beatitudes, June Dusk," "Horses, Considering Winter," "Feeding Horses, During Snow," "Frost at First Sun," "108°—The Horse Pasture," and "Anecdote of the Horses" all appeared in *The Midwest Quarterly*.

"Why We Bought a Horse" and "Meteor Shower, and Horses" appeared in *Jabberwock Review*.

"The Horse Considers Hell" appeared in *River Styx*.

"A Thousand Reasons," "In Hurricane, with Horses," "Early Morning on Farm Road," and "Counting Horses" appeared in *Shenandoah*.

"The Horse as the Letter L" appeared in *Solo Novo*.

"On Horseback, Hell's Gate Canyon, October" first appeared in *Poetry East*.

"The Horse Knows" appeared as a longer poem in *WaterStone Review;* a section of the longer poem published in *WaterStone Review* appears here as "Etude for Winter," and other sections appeared in *Red Rock Review*.

"Jed, Last February" appeared in *The Comstock Review* and the 2012 *Nebraska Poets Calendar*.

"Plain Sense" was first published in *The Midwest Quarterly*, but horses have since populated two new segments in the work. The original poem also appears as a single-poem chapbook from Sandhills Press, 1998, and in *A Sandhills Reader: 30 Years of Great Writing from the Great Plains*, edited by Mark Sanders (Stephen F. Austin State UP, 2015) and *Nebraska Poetry: A Sesquicentennial Anthology 1867-2017*, edited by Daniel Simon (Stephen F. Austin State UP, 2017).

"Old Wives' Tale" appeared in *Prairie Fire*.

Certain of these selections appeared in *Here in the Big Empty* (Backwaters Press, 2006), *Conditions of Grace: New and Selected Poems* (Stephen F. Austin State UP, 2011), and in the fine press edition of *Landscapes, with Horses* (LaNana Creek Press, 2012).

CHARLES D. JONES is an artist/musician living and working in Nacogdoches, Texas, where he designs, prints, and binds fine press and artists' books for LaNana Creek Press. He has exhibited his art extensively, nationally and internationally, most recently in Russia, Italy, and France, and his fine press editions are in collections of the Bodleian Library, Oxford University, the Victoria & Albert Library, the Pushkin Museum, the Taiwanese National Library, as well as special collections throughout the United States. His book on the war in Vietnam, *Chopper Blues*, was awarded the International Book Prize for Military History, 2013, by the *Los Angeles Book News*. His most recent book is *East Texas Retrospective*, featuring fifty years of his artwork and analysis of his contribution to the creative culture of East Texas.

MARK SANDERS is a Nebraska native, currently Chair and Professor of English and Creative Writing at Stephen F. Austin State University in Nacogdoches, Texas. He has lived, in addition to his home state, in Missouri, Oklahoma, Idaho, and Texas. His most recent book is *A Sandhills Reader: 30 years of Great Writing from the Great Plains* (2015), which won the 2016 Nebraska Book Award. Among his other works are *The Suicide, Before We Lost Our Ways, Here in the Big Empty, Conditions of Grace: New and Selected Poems, Riddled with Light: Metaphor in the Poetry of W. B. Yeats, The Red Book: The Selected Poems of Kathleene West, The Weight of the Weather: Regarding the Poetry of Ted Kooser*, and, forthcoming in 2018, *Verdigris Creek Bridge: A Literary Reunion*. He and his wife Kimberly live on a small horse farm near Nacogdoches.